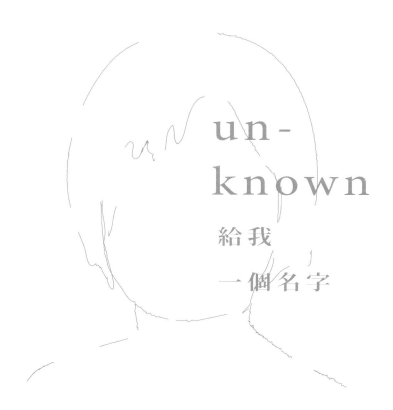

un-
known

給我

一個名字

Isabelle Lee 李雅康

Contents 目次

自序

我是個夢想很多的人，也會認真付諸實現。我擔任過不同的職業：護理、翻譯、導遊、貿易、農業生產……等。上天疼惜，於工作過程中大都心想事成，這亦可能是補償我在法國生活的某些缺憾吧！我很不易滿足於現狀，會不斷地向上追求，向上是我的夢想，也是我的目標，我如上階梯似的一步步堅持著！

人生無常，2013年的10月醫生宣告我得了癌症！瞬間，我如同從高高的階梯上摔了下來！放掉手中想要抓住的一切，頭腦從未來進行式切換為現在進行式，注意力回到當下，一連串的醫治、休養、讓身心靈遭受到無比的傷害。這時，油畫創作為我開啟一條「心的出路」，把話都說給畫布和油彩聽，由它們替我表達內心的想要與感受，畫刀用力盡情地揮灑，將我的心事抖露無遺，我的心好滿足舒暢！

Autobiography

I'm a person full of dreams and ambition, and I put in my best foot forward to make sure them come true. Throughout my life I've been in different occupations : nurse, translator, tour guide, trades, agricultural..etc. Through the grace of God, I was able to accomplish and succeed in the different roles I was in. I think in a sense, this helped make up for some of the hollowness I felt in France. I'm a person who tend to be unsatisfied in my comfort zone. Therefore, I am always looking for new things to try and overcome. Moving forward and perservering became my goal in life. Determination to succeed became my driving force. I strived to fulfill my life goals and purpose relentlessly.

Despite all my efforts, life is full of unexpected events. I was diagnosed with cancer in October of 2013. All of a sudden, I felt like I fell from the pedastal I had built for myself. In that instant, I let go of everything I was trying so hard to grab onto. My brain shifted from looking at the future to focusing on the present. The series of treatment processes had a great toll on my phyical, emotional, as well spiritual wellness. Throughout this experience, creating art became my way of conveying my emotions. I was able to express my stories and emotions onto the canvas, and have my art disclose my inner thoughts for me. I utilized strong strokes as a way to release all my pent up feelings and emotions. Being able to do this satisfied and fulfilled my heart.

2014年我加入 MARNE LA VALLEE 藝術家協會，2015和2016年參加當地地區性油畫聯展及2018年廣州藝博會，我的作品風格以抽象或半抽象色彩繽紛鮮豔為主軸，常以生活中的人事物聯想做主題，我喜歡單一創作來實現美學的個性化與無常性。

當今，我的人生新目標是成為一位專職的藝術創作者。因為藝術是無價、無競、又無限，擺脫世俗的價值觀，在無競爭的單純環境裡、發揮空間是無限的！如此自由、寬廣、美麗的心靈之旅。還有，這趟旅行我不孤單，有好多懂我畫的人陪著我！！

In 2014, I joined the Artist Federation of Marne la Valee. With them, I was able to take part in the Exposition Union for Oil Paintings. My art style is abstract and semi-abstract. I specialize in utilizing vibrant colours as a focus of my work. Most of my work consist of people and things I come across in my daily life. I like creations that provoke beauty, character, and variance.

Today, my new goal in life is to become a professional creater of art, because art is not only priceless and anti-competetive, it is also limitless. Art is where I can throw away the norms and values of society. The space to create is limitless in a pure, and anti-competetive environment. With art, I feel like I'm on a journey filled with freedom, unlimited horizons, and beauty. However, I'm not alone on this journey ! There are so many of you who understand my art accompanying me.

這本畫冊名叫「給我一個名字」有三個含意：

1.每個人對抽象畫的密碼解讀都不一樣，你在欣賞畫的同時，畫在跟你說話，它說：給我一個名字！

2.從事油畫創作是我新生命的開始，藉著每幅畫的意象，讓我更認識自己，好想給我自己一個新的名字！

3.我真的茫然，不知道如何給畫冊取名字，在沒有答案中找到答案，決定畫冊就叫做「給我一個名字」，有心的賞畫讀者，歡迎你們給我的畫冊取個名字，讓這個名字刻在你們的心中，想起這個名字就想起我的畫。

..

祝福大家平安快樂

李雅康　2018年8月19日　於 法國巴黎

The title of this is called" Unknown ". There are three meanings behind the creation of this name

1.Everyone has a different take on abstract work. When you are appreciating art, it's as if the art is speaking to you personally.
It says : give me a name !

2. The chance to start oil painting is a mark of the start of my new life. I'm getting to know myself better by using symbolism and meaning in my work. I a constant desire to give myself a new name !

3. I admit, I was confused. I did not know how to name this cluster of work. I was able to find the answer when I did not have one. That's when I decided, this will be named « Unknown ». If you are someone who appreciates my work, I welcome you to give them a name. Let this name be written on your hearts and remind you of my art whenever you think of it.

..

May peace and happiness follow you.
Isabelle LEE.
August 19th, 2018.
Paris, France.

附註：謝謝志杰弟接受邀稿為我的畫冊撰寫推薦序，他是非常優秀的外科醫師，平日忙於工作與專業研究，這次撥冗作序，由衷感謝！志杰雖然習醫，但因其母親為水墨畫家，自幼受其薰染，深具文學與藝術涵養，更難得的是志杰總能懂我的畫，與我心意相通，寫作此序實為不二人選。

PS. A big thanks to Chi- Jie for his words in of recommendation. He is a spectacular surgeon. Despite his busy schedule, he willingly shared his valuable take on my work. Even though he studied medical, his mother was a artist who specialized in watercolour. He came to contact with art at a very young age. What is more valuable is that he understands my work, and the things I'm trying to convey. Without a doubt, he is the perfect person to have speak about my work.

推薦序

「絢爛奪目、流連而忘卻當下」乍看雅康姐畫作，在腦中油然而生此深刻的印象。

雅康姐，是個生活藝術家，擁有多彩多姿的身份背景，除了有旅居法國數十載的生活經驗，身為蘭花花藝實業企業家，浸淫在歐洲法國這浪漫國度，潛移默化中儲備其創作的能量，對其與生俱來的藝術才華，亦如醍醐灌頂，讓她在繪畫的天地裏揮灑著自由獨特的畫風。在移居法國之前，雅康姐從事開刀房的護理工作，要接觸具生命力但帶有疾病的人，且長期在高壓的狀態下工作，歷經「生老病死」的無常。這些生活背景孕育陶冶出其蒼勁犀利的筆觸，在油畫裏顯露出與眾不同的畫風。

Words of Recommendation

"The vivid boldness captures the eyes of its audience; its beauty strikes and takes centre stage despite their different stages of life". For me, this is the powerful feeling Isabelle's work provokes.

Isabelle is an artist in various aspects of life; she comes with a colourful background. Not only has she spent years dwelling in France, she is also a professional business woman specializing in orchid flowers. The romantic environment in which she situates herself in is depicted through her creation and artistic energy. Her talent to portray freedom in her work has the power to enlighten her audience with lasting inspiration. Before immigrating to France, Isabelle was a nurse who worked in surgery rooms with individuals who struggled with different illnesses. She worked under immense pressure on a daily basis, and vicariously lived through "life and death". These experiences shaped her courage to utilize sharp and penetrating strokes in her work to achieve different styles.

林志杰
Chih-Chieh Lin

雅康姐，並非是科班出身的油畫家，少了那份匠氣，但是跳脫出框架，畫出那份從容不迫的自由感，暢然悠遊於繪畫世界。我認為每幅畫都會釋放出它們獨特的頻率，賞畫者因而得到共鳴，事實上，雅康姐的每幅畫作都能讓我有強烈的共鳴，其中令我印象深刻的是其中有兩幅畫，一為較寫實的畫是描繪一對情侶背對著賞畫者在寒納河畔往著遠方散步，畫作是多麼絢爛繽紛，襯托出畫中的情侶戀愛中的情境，絕妙的是情侶的表情巧妙的無明確點繪出來，更是留下賞畫者無限的想像空間。另一幅畫則是較抽象的畫作「拒」，這幅畫作則留給賞畫者更大的想像空間，畫中留有的仍是雅康姐獨有的色彩構思技巧加上跳躍的筆觸，隱約從畫作察覺出兩位人士，一位背對著另一位，透露著是否一位正在「拒」絕著另一位，真的是解讀存乎一心。

令人振奮的是，這本畫集的問世，相信可以為讀者帶來更豐富的藝術饗宴，值得推薦給大眾，實在是不容錯過的畫集。

Being an artist was not Isabelle's initial career path. However, Her craftsmanship steps outside the box and effortlessly convinces her audience of her freedom to create and communicate through her work. Every piece expresses their uniqueness and relatability to their audience. Actually, I find every work of Isabelle's strongly relatable. There are two pieces that come to mind. One is of a couple having their back to the audience; admiring the Seine River while taking a stroll. The vibrant colours communicate feelings of love to its viewers. The meticulous thing about this piece is that the facial expressions of the couple are blurred, which allows its audience to build their own story for this piece.

The other piece that come to mind is "Rejection". This piece gives the audience even more space to create their own dialogue. The energetic strokes and meticulous use of colours make up two individuals, with one having their back to the other. The portrayal of the word "rejection" is vivid, while still allowing the audience to have their own imagination of the dialogue between the two characters. "Rejection" artistically shows off the wholeheartedness Isabelle puts into her creations.

The most intriguing and exciting thing about this album is its powerful potential to fulfill its audience's hearts. I stand by Isabelle's work and highly recommend them to every individual. "Unknown" is definitely an album you do not want to miss.

快樂我要
My Pursuit of Happiness

常說自尋煩惱，何不做個自尋快樂的人；畫中右側的人正在接近快樂的泉源，畫的中央則以橘色呈現快樂的意象，人們正手舞足蹈歡樂不已，而有人本來很快樂，但卻又自尋煩惱 — 當她離開快樂泉源，又變成如畫左側的大黑影，快樂泉源在哪裡？凡事感恩，知足常樂。

We always say : instead of searching for reasons to be sad, why not search for reasons to be cheerful ? The girl at the bottom right is seen approaching the fountain of joy, accomodated by orange hues in the centre of the painting illustrating happiness . Characters are seen dancing cheerfully , while some search for reasons to be sad although they started out happy . When she leaves the fountain of happiness, she then turn to the overwhelming black shadow on the left. Where can we find the fountain of joy, you ask ? Be thankful and content for the little things.

畫名：快樂我要
材質：壓克力畫／棉布
尺寸：55x46 cm
作者：李雅康
年份：2018

浪漫之路
Romantic
Path

秋天的夜晚，陰、溼、充滿涼意，柔暈的燈光灑在景物上
幻化出繽紛的色彩，載滿紅葉的樹林與湖上的燈火掀起更
多的遐想，湖水的波紋、地面的水痕、情侶依偎漫步其中
增添整幅畫立體的動感。遠遠的、靜靜地欣賞，不知覺的
走進畫裡， 隨著情侶步上浪漫之路！

Autumn nights are dark, humid, and chilly. Soft, florescent reflection of light
make up the vibrant colours of this piece. Accompanied by trees of red, drops
of light reflects on the lake, ripples of water, water on the streets, and lovers on
a walk. The whole scene together creates a sense of heart-rending dimensions.
Unconsciously I pictured myself in this piece, trailing behind the lovers
quietly from afar on this Romantic Path.

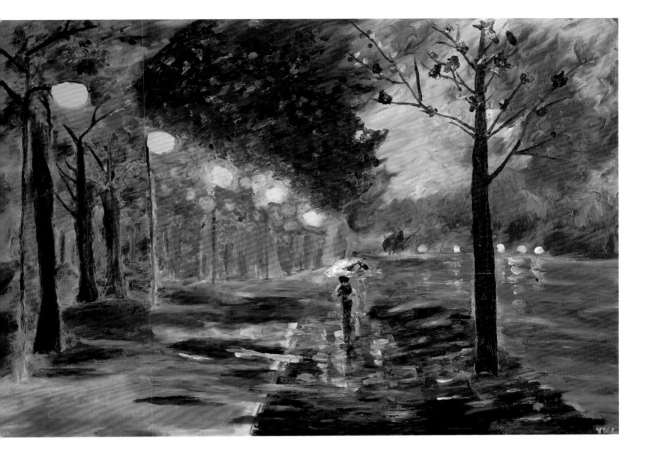

書名 : 浪漫之路
材質 : 油畫 / 亞麻布
尺寸 : 115x80 cm
作者 : 李雅康
年份 : 2017

春回大地
Return of
Spring

運用鮮豔單純的基礎色，凸顯春天的天空、海洋、山丘草原，和遍地的春花，畫刀用力刻畫，強調冬天已去，春天來了！

Using simple, sharp, basic colours to create the sky, sea, hills, and flower fields of spring. Bold strokes emphasizes that winter is gone ; spring is here.

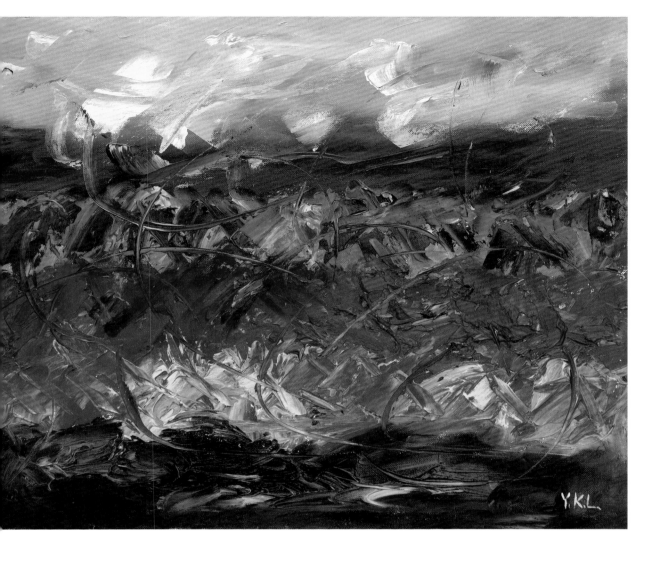

畫名 : 春回大地
材質 : 油畫 / 棉布
尺寸 : 55x46 cm
作者 : 李雅康
年份 : 2018

窗裡窗外

Window
View

夜晚，透過薄紗窗簾向外看，窗外的亮光和朦朧的幻景，
似乎讓人嚮往！其實，該把握看重的是窗內的一切，因為
那才是真正屬於我的！

The view at night through the chiffon curtains is filled with lights and
mystic views ; longed for by most people. However, it's important to value
and treasure the things on the other side of the window, because those are
what I can truly call mine.

畫名 : 窗裡窗外

材質 : 油畫 / 亞麻布

尺寸 : 38x46 cm

作者 : 李雅康

年份 : 2018

春浪
Waves of
Spring

春天充滿生氣與力量，藍色的天空與海洋的中間，春天的
浪花歡樂的跳躍著，我的耳邊響起義大利音樂家韋瓦第的
四季協奏曲─春。

Spring is filled with energy and power. Between the blue sky and sea, waves of
spring dances with joy. It's as if I can hear Antonio Vivaldi's «Spring » from
Four Seasons playing in my ear.

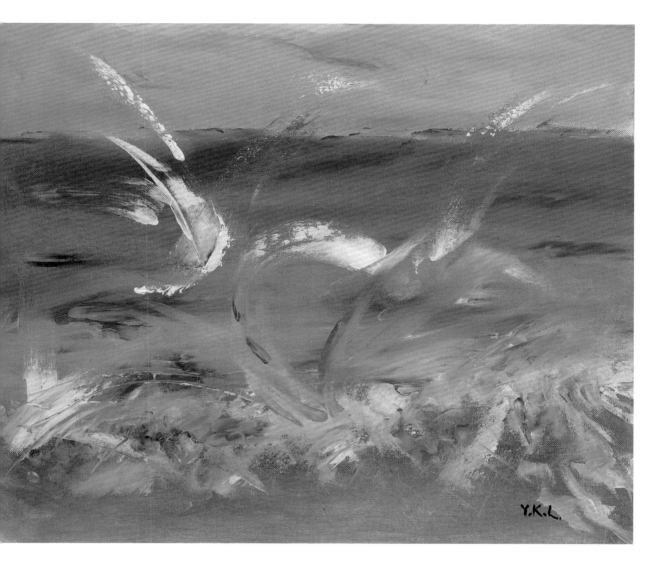

畫名：春浪
材質：油畫／棉布
尺寸：55x46 cm
作者：李雅康
年份：2018

秋宴
Fall Festival

艷紅色的大理花和黃土色的菊花插滿瓶，自然的宴席告
訴你：秋來了！

Vibrant red Dahlias and mustard yellow Chrysanthemums fill the
vase. It's as if nature is telling you : Fall is here !

畫名:秋宴
材質:油畫 / 亞麻布
尺寸：80x60 cm
作者:李雅康
年份:2017

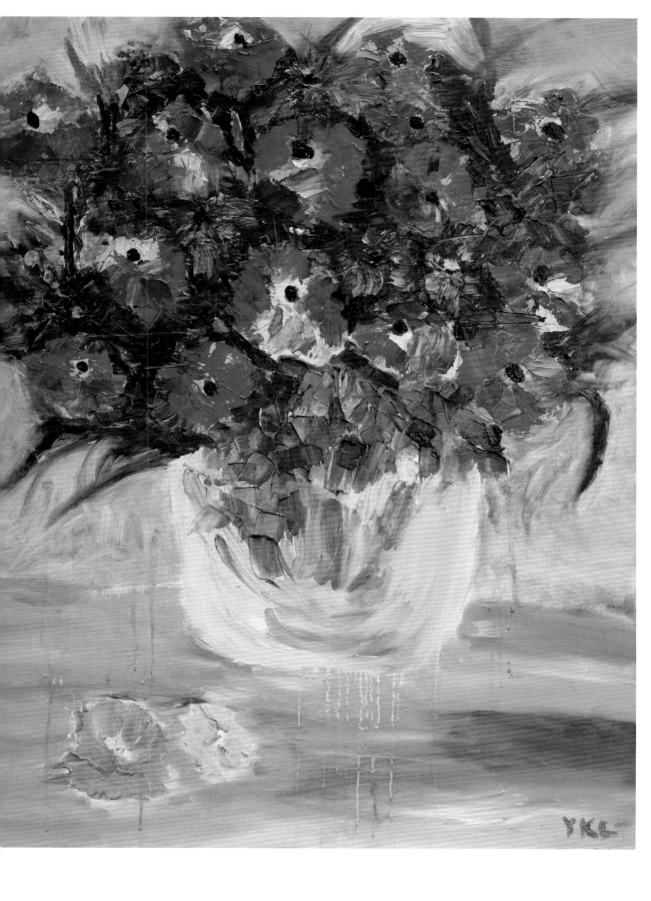

我
Self Portrait

2017年11月在台北出差，三更半夜來自法國的緊急電話要求立即處理事務，當時的我，真是灰頭土臉，半睡半醒間完成工作，隨後畫下這幅灰頭土臉的我。

I went to Taipei for work in Novemer, 2017. In the middle of one night, I got an emergency call from France regarding something I had to attend to immediately . At the time, I finished the task while half asleep, followed by painting an overwhelmed, tired reflection of myself

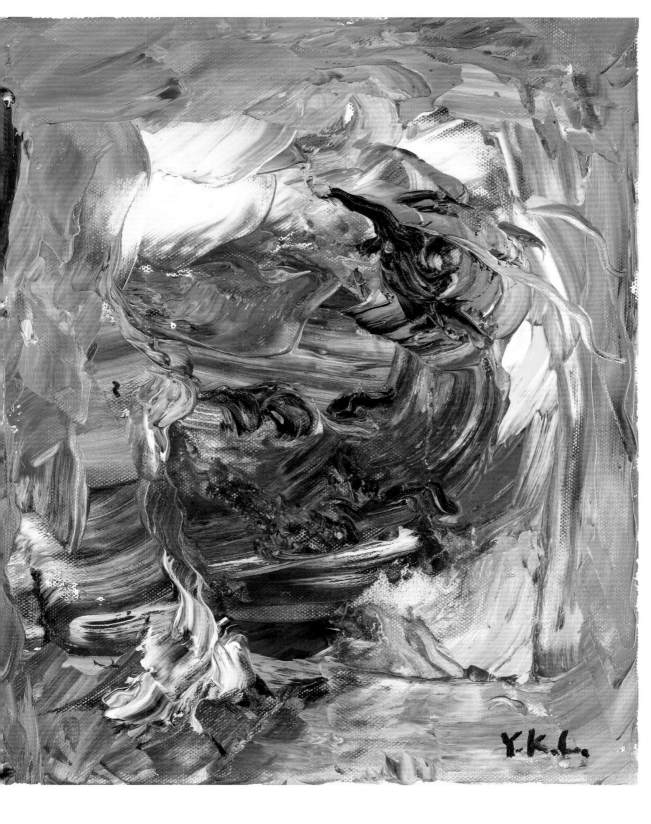

畫名：我
材質：油畫／仿亞麻布
尺寸：27x22 cm
作者：李雅康
年份：2018

夜歸
Wanderer of
the Night

夜歸女人的背影，獨自行走在幽暗的街道中，猜猜他因何而夜歸？因工作、約會、或是……，迷失了方向？

On a dark road in the night, a lady walks alone. It seems as if she's trying to get somewhere in the night. Want to guess where she's returning from ? Work ? A date? Or... has she lost her way ?

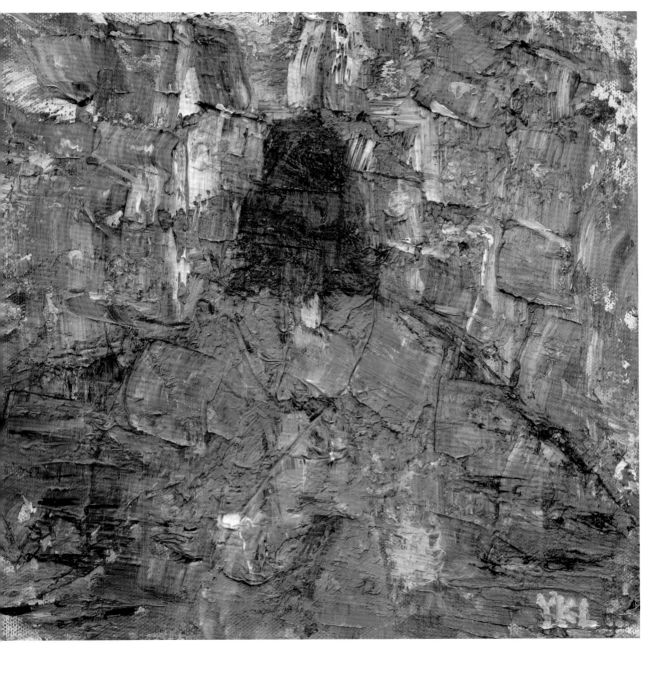

畫名 : 夜歸
材質 : 油畫 / 棉布
尺寸 : 30x30 cm
作者 : 李雅康
年份 : 2017

無價之寶
True
Treasure

知識是無價之寶，簡單的刷痕，揮灑出圖書館內的氛圍與景象。

Knowledge is the true treasure. Simple strokes create the ambiance and scenery of the library.

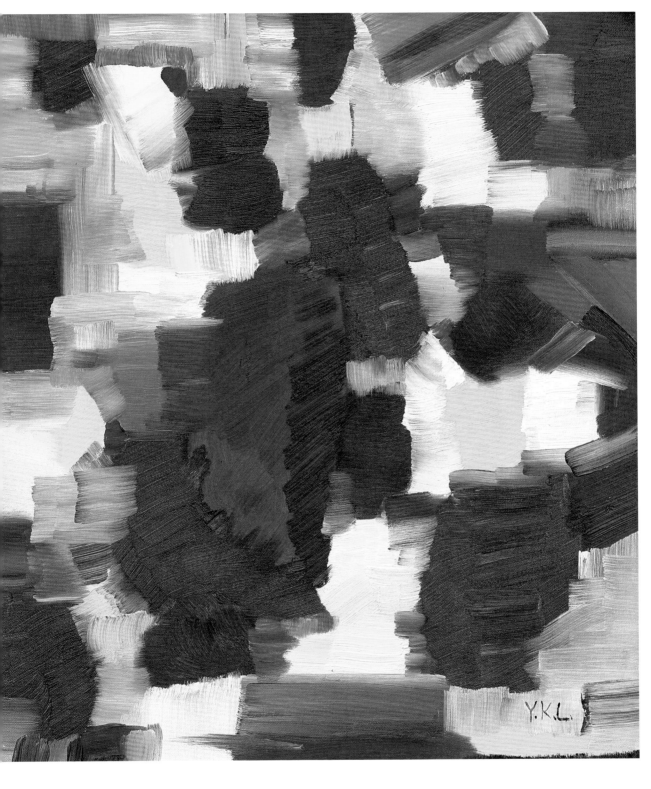

畫名：無價之寶
材質：油畫／棉布
尺寸：55x46 cm
作者：李雅康
年份：2018

花嫁
Flowers of
Marriage

2018的5月，幾位年輕的好朋友結婚了，身在遠方的我，只有用畫表達對他們的祝福。花嫁是其中之一，這是一束新娘捧花，新娘們捧著花束嫁給心愛的人。花嫁向新郎們訴説著：這一天，我如花綻放，豐盛美麗，定意要嫁給你，你要好好疼惜我，這是我一生一次的選擇，雖然，花會謝，人會老，但我對你的愛情永遠堅貞不變！

In May of 2018, some of my young adult friends got married. I could only send my blessings through paintings due to being abroad. Flowers of Marriage is one of them. This is a piece of a weding bouquet. The bride holds the bouquet while getting married to the love of her life, as if the bride is making her vows to the groom through them : even though flowers may wither, we may age, but my love for you is everlasting.

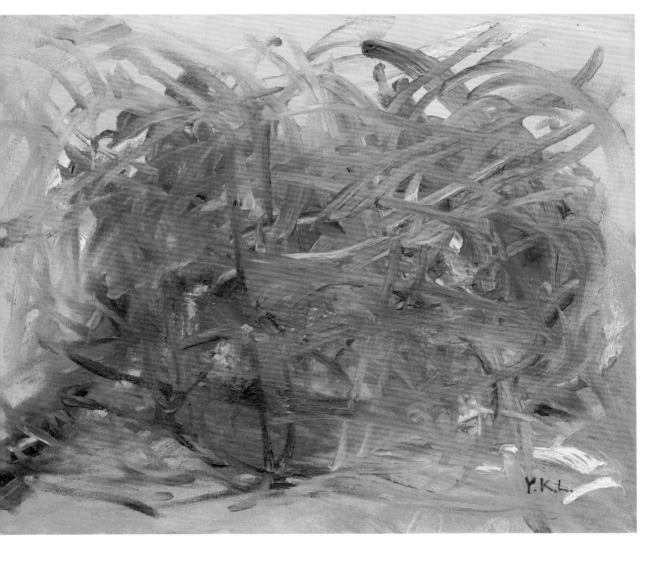

畫名 : 花嫁
材質 : 油畫 / 棉布
尺寸 : 55x46 cm
作者 : 李雅康
年份 : 2018

海市蜃樓

Mirage

海市蜃樓會在水面或沙漠中出現，因空氣和光線的折射；
當海市蜃樓出現在心中時，投射的是我內心的「想要」，
美麗而不必然實現的心靈慾望。

Mirage usually appears on water and desert due to air and reflection of
light. However, when mirage appears in my heart, it usually projects my
deepest, beautiful, but potentially unachievable « desires ».

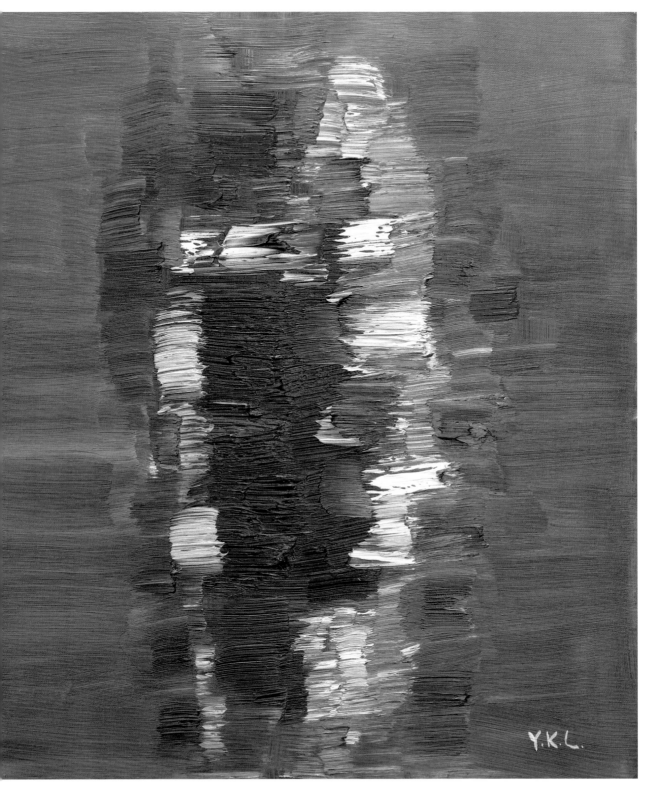

畫名：海市蜃樓
材質：油畫 / 亞麻布
尺寸：38x46 cm
作者：李雅史
年份：2018

豐年慶
Celebration of Harvest

這是景色優美的小村莊，水源富足，年年豐收；已是午夜時分，熱鬧的豐年慶大功告成，大多村民已返家休息，但依然有人捨不得歡愉的氣息，帶著醉意繼續歌舞，黯淡柔和的夜晚，伴著餘音繚繞的歌聲，期盼明年加倍好豐收。

This is a village with great views. The plentiful water result in great harvests every year. It's now midnight. The lively Celebration of Harvest has come to an end. Most of the villagers have gone home to rest. However, a few still linger to continue the celebration. The gentleness of the night, accompanied by echoing sounds of song hopes for another year of plentiful harvest to come.

畫名：豐年慶
材質：油畫 / 棉布
尺寸：55x46 cm
作者：李雅康
年份：2018

願景
Picture
Perfect

初秋略帶涼意的午後，丈夫摟著新婚懷孕的妻子河邊漫步駐足賞景，安慰疼惜妻子懷孕的不適，想像著不久的將來小生命誕生後幸福快樂的願景！

The beginning of Autumn is filled with light breeze. A husband can be seen caressing his wife with child by the river. While admiring the scenery, he comforts her as she experiences discomfort from her pregnancy. He can only imagine the great, loving days to come when this new life enters the world !

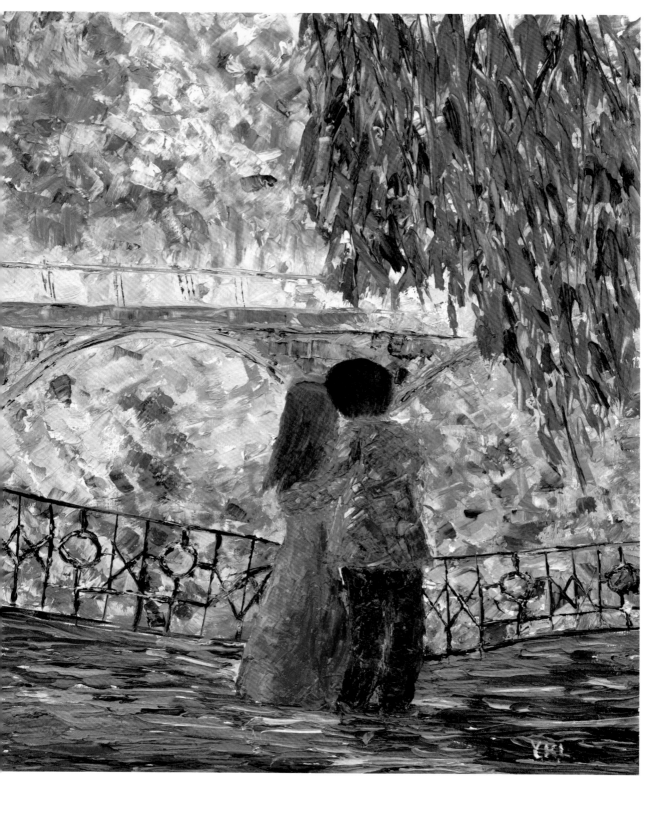

画名：题景

材质：油画／亚麻布

尺寸：38x46 cm

作者：李雅康

年份：2018

金銀島
Treasure
Island

佈滿金銀財寶的寶島－台灣！畫中的金色、銀色、紅色、紫色……象徵富貴的彩系，抽象呈現各種財寶資源，願台灣同胞幸福快樂，不虞匱乏！

aiwan – an island filled with treasures of immense value. Colours of gold, silver, red, and purpal symbolize palettes of luxury, abstractly illustrates the overflow of resources on this Island. May the citizens of Taiwan live abundantly ever after!

畫名：金銀島

材質：油畫／亞麻布

尺寸：38x46 cm

作者：李雅康

年份：2018

畫名：黃昏之戀
材質：油畫／亞麻布
尺寸：100x72 cm
作者：李雅康
年份：2017

黃昏之戀
Sunset
Romance

天與海相戀。愛情是美麗的，黃昏是浪漫的，美麗與浪漫的完美結合便是黃昏時刻。

The love story between the sea and sky. Love is beautiful, while the sunset is romantic. The perfect harmony between beauty and romance is depicted by the setting of the sun.

恕
Forgiveness

心中充滿著不平，怨恨、負面思想充溢全身！拿起畫刀，揮灑一番，將心情宣洩在畫布上，憂鬱強橫的色彩，混亂的刀觸，凹凸不平的畫面！心情平靜後，悟出了一個道理：那就是寬恕，故友人為這幅畫起名叫「恕」，畫如其名。

Heart filled with unfairness. Anger and negativity fills the entire being. I pick up the brush and created unsynchronized strokes as an expression of emotions on the canvas. Strong and sorrowful colours, chaotic strokes, uneven depictoins fill the canvas. After calming down, the word, « forgiveness » came into my head. A friend then named this painting « forgiveness », which is exactly what it's about.

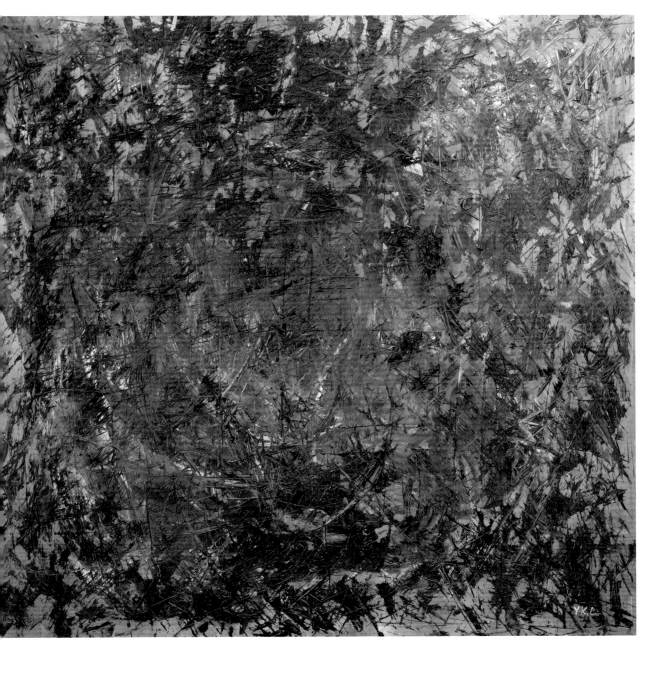

畫名：恕
材質：油畫 / 棉布
尺寸：100x100 cm
作者：李雅康
年份：2018

汪洋中的一條船
He Never
Gives Up

很懷念年輕時的那部電影《汪洋中的一條船》，講說鄭豐喜先生的奮鬥史。人生的磨難與考驗不也如此？如同船在黑夜遇到狂風巨浪，這時只要認定並掌握正確方向，勇敢不放棄的向前航，定能成功！

Reminiscing a movie I watched in my youth called, « He Never Gives Up ». It talks about the stuggles and ambitions of Cheng Feng Xi. Isn't it similar to the struggles and challenges we face in life ? Just like the boat facing the storms. As long as we are set and sure on our destination, with courage and the spirit of never giving up, success will be on the horizon.

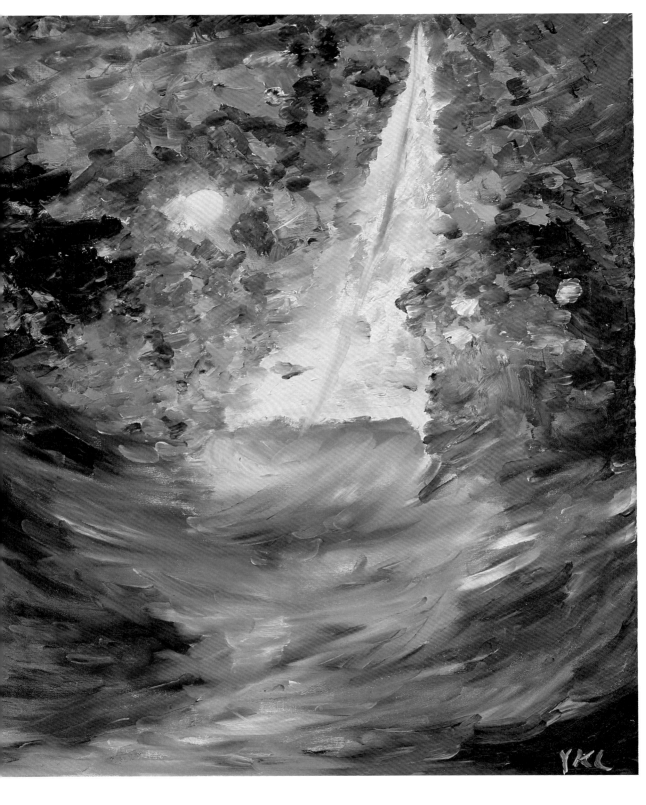

畫名：狂濤中的一條船

材質：油畫／帆布

尺寸：50x60.5 cm

作者：李雅史

年份：2017

鸚鵡林

Forest of
Parrots

傳說中，有個鸚鵡林，白色的樹葉枝幹能吸引各式擁有美
麗羽衣的鸚鵡前來棲息。

Legends told of a Forest of Parrots, where pale branches attract the most
exotic and beautiful parrots to come and dwell.

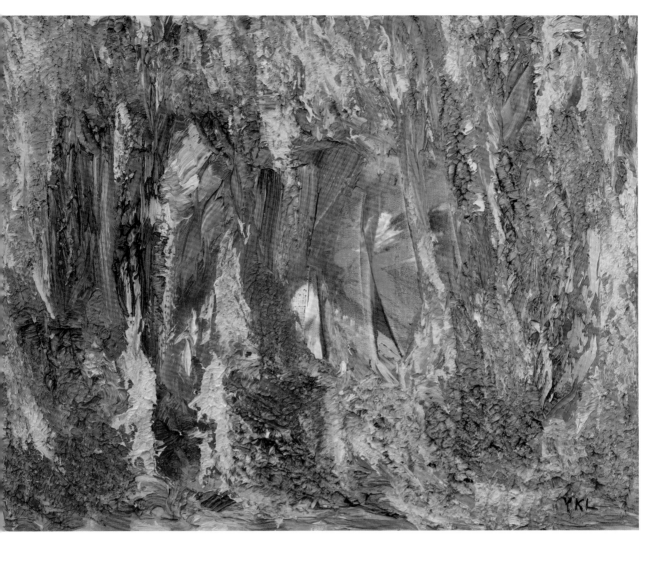

畫名 : 鸚鵡林

材質 : 油畫 / 亞麻布

尺寸 : 38x46 cm

作者 : 李雅康

年份 : 2018

畫名 : 抱抱我
材質 : 油畫 / 仿亞麻布
尺寸 : 41x31.5 cm
作者 : 李雅康
年份 : 2018

抱抱我

Hug me

心情不好嗎？找個懂你愛你的人？跟他說：「抱抱」！

Are you having a bad day？Find someone who understands and loves you, and ask them for a hug!

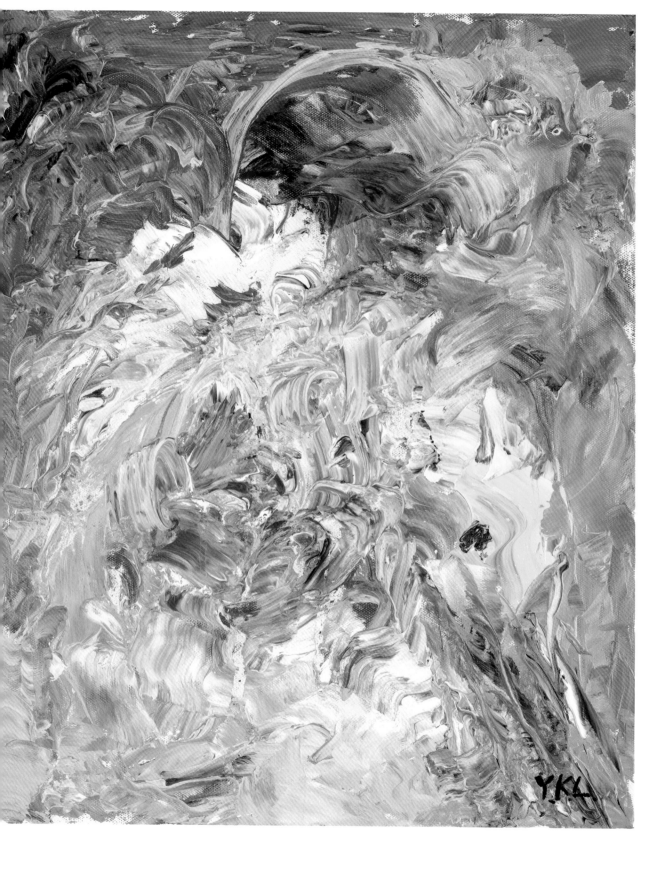

思想起
Nostalgia

想起小時候晚飯後在小巷中散步，鄰居親切的招呼。孩童的頑皮逗趣！小朋友畫筆下的房屋，母親推著嬰兒車嘴中哼唱著小曲，輕風搖曳著藍紫色的紫羅蘭花樹，與黃色的迎春花樹相互輝映，寧靜祥和的夜晚，相信今晚定有好眠！

Reminiscing of walking around my alley after dinner as a child, it's filled with warm neighbours and playfull kids. In the house below the paintbrush, a mother pushes a stroller while humming a lullaby. Gentle breeze moves the Violets, who are welcoming Spring alongside trees of yellow. A good night's rest will definitely take place on this peaceful night.

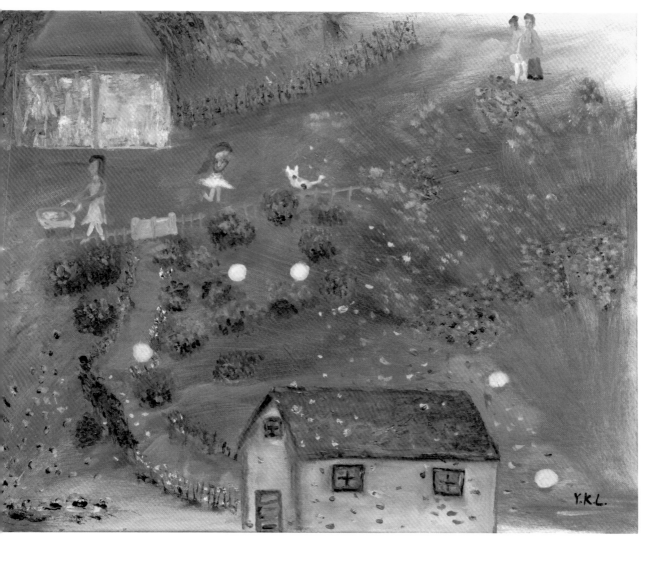

畫名：思想起
材質：油畫／棉布
尺寸：46x55 cm
作者：李雅康
年份：2018

戲耍

Playfulness

舞台上五顏六色的燈光，照亮台上戲耍的人，抽象而動態的顯出它們賣力的演出，我聽到台下掌聲不斷。

Lights of all colours flashes on the stage, giving spotlights to playful actors. Abstract movements portray their act filled with hard work, as sounds of applause from the audience fails to cease.

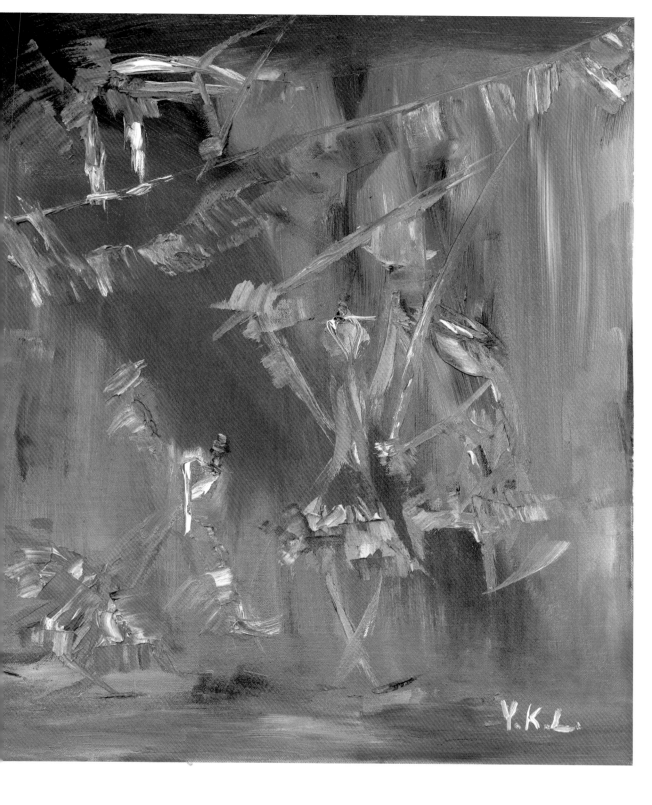

畫名：戲耍
材質：油畫／棉布
尺寸：55x46 cm
作者：李雅康
年份：2018

畫名：最後華爾滋
材質：油畫 / 棉布
尺寸：70x50 cm
作者：李雅康
年份：2017

最後華爾滋
The Last
Waltz

醉人的音樂，翩翩舞動的紗裙，旋轉啊旋轉，讓我們珍惜
今夜最後的擁抱－最後的華爾滋！

Mesmorizing music accompanied with twirling of chiffon skirts. Let us
cherish this last few moments of caress- The Last Waltz !

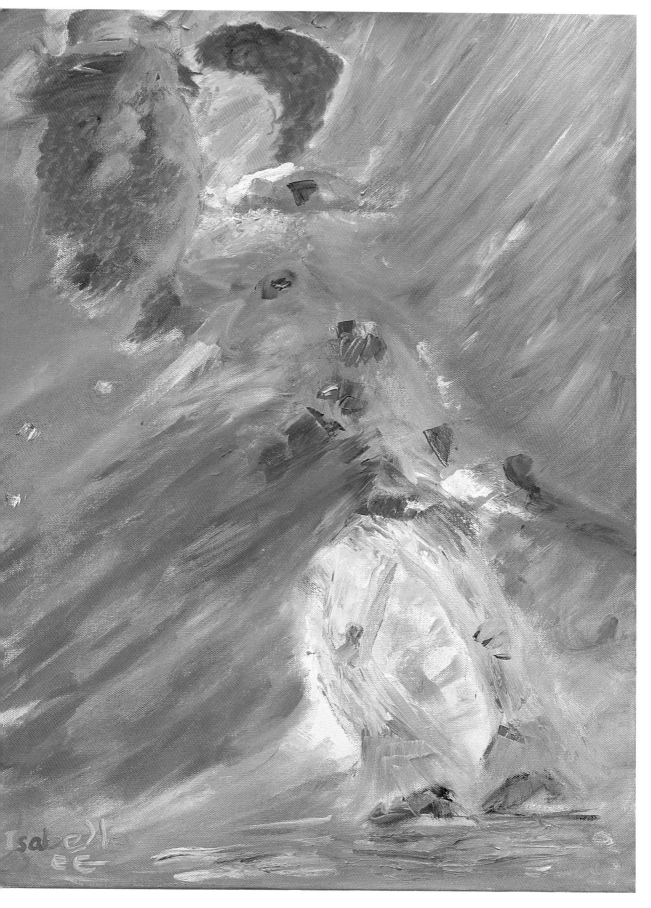

畫名：故鄉
材質：油畫 / 亞麻布
尺寸：100x81 cm
作者：李雅康
年份：2018

故鄉
Place of Origin

哪裡是我的故鄉？2015年回到高雄出生長大的左營，卻尋不回兒時的景物！居住過的老屋都拆遷了，棟棟高樓取而代之，培育我的母校擴建更新卻讓我好陌生，街邊的小吃似乎味道也變了！左營成為交通的樞紐，人多車多，哪裡找回記憶中純樸又充滿朝氣的左營？2018年4月創作這幅抽象畫，如在夢中回到故鄉。

Where is my place of origin? In 2015, I went back to Zuoying, Kaohsiung, where I grew up, but I did not recognize it. The home I grew up in was replaced by highrises, my old school looked updated and foreign, and the taste of my go-to food stand changed. Zuoying became a transportation centre filled with busy people and rushing cars. Where can I find the Zuoying I know filled with positive energy? This abstract piece was created in April 2018, in an attempt to return to my Place of Origin in my dreams.

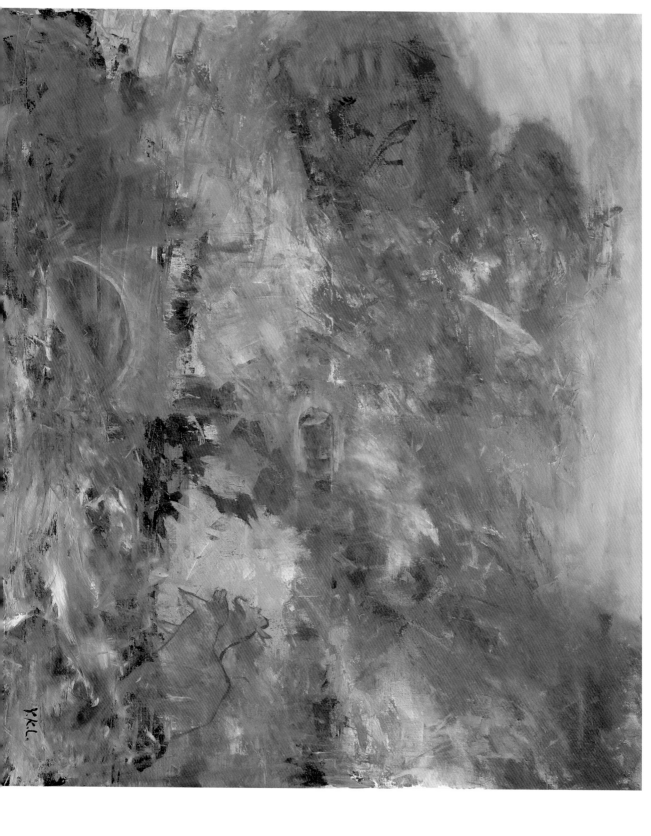

拒
Rejection

左邊的男士不被美色吸引故背對著妖嬌美豔的女士。引申
畫意：要懂得拒絕，才能掌握原則。

The gentleman on the left purposely has his back to the glamorous lady,
without falling into temptation. Moral of the painting : one needs first to know
how to reject in order to grasp the importance of personal boundaries.

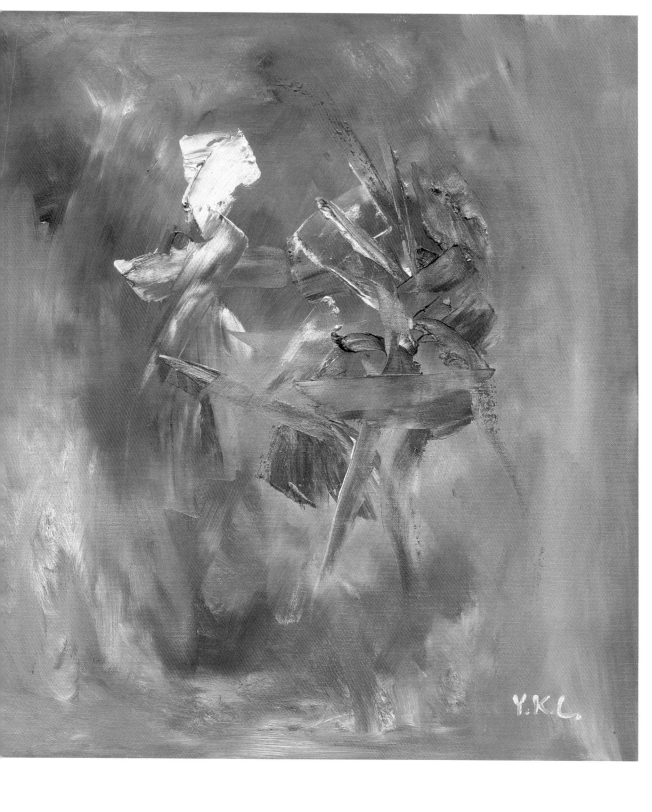

畫名：扣
材質：油畫 / 棉布
尺寸：46x55 cm
作者：李雅康
年份：2018

畫名：故夢重尋
材質：油畫 / 亞麻布
尺寸：38x46 cm
作者：李雅康
年份：2017

故夢重尋
Dream
Seeking

那年夏天也是這樣的雨，我們相遇編織美麗的夢。如今夢
醒，人在何處？我欲故夢重尋。

The same rainy days filled the summer we met and weaved that
beautiful dream. Where are you, now that we've woken up ? I'm still
seeking after that dream.

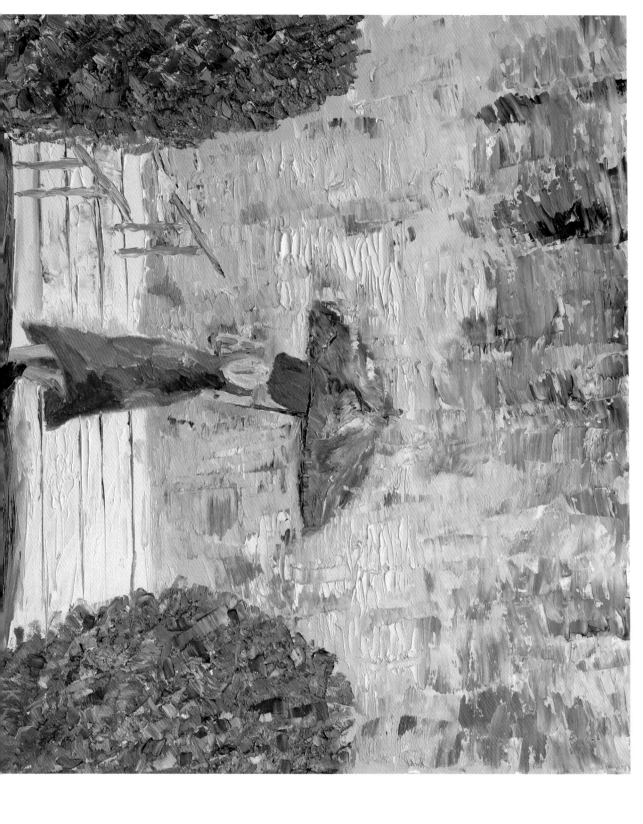

冰雪奇緣

Memories
on Ice

描繪人們歡樂溜冰的場景。

A painting of cheerful individuals ice-skating.

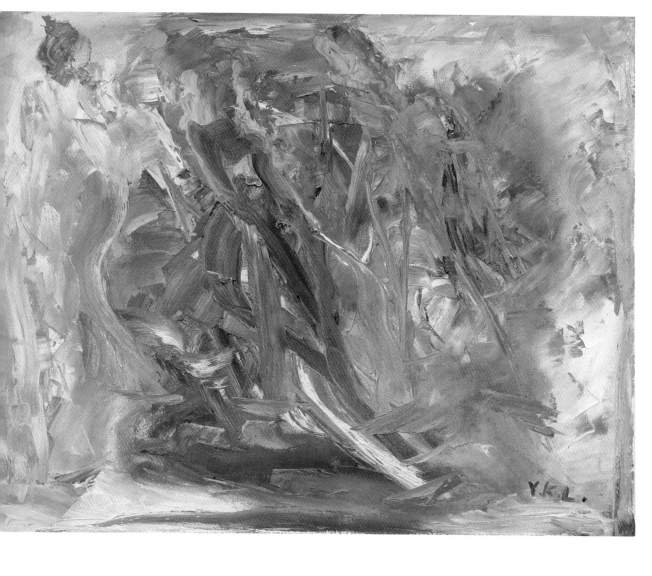

畫名 : 冰写奇缘
材質 : 油畫 / 棉布
尺寸 : 55x46 cm
作者 : 李雅康
年份 : 2018

激
Splash

這是立體動態的表現，海浪擊打在岩石上，甚或丟個冰塊在飲料中，都會產生撞擊後的美麗的「激象」，生活中的挫折與打擊都是美好的動力，使我們在性情上學習堅忍與勇敢，更得智慧的頭腦處理突發狀況。巨浪拍岩激起的美麗浪花越過岩石後依然是平靜的海水，所以，不要懼怕，要懂得欣賞老天給我的激象。

This is a demonstration of movement. Beautiful moments of splashes occur after various contexts of contact, such as the waves hitting the rocks, or ice dropping in drinks. Struggles and hardships in life are all great motivators, forcing us to learn how to persevere and have courage. Moreover, to have a wise mind to handle crisis situations. Though giant tides splash into rippled waves when hitting the rocks, still water awaits on the other side. Therefore, don't be afraid, and learn to understand the splashes given in life.

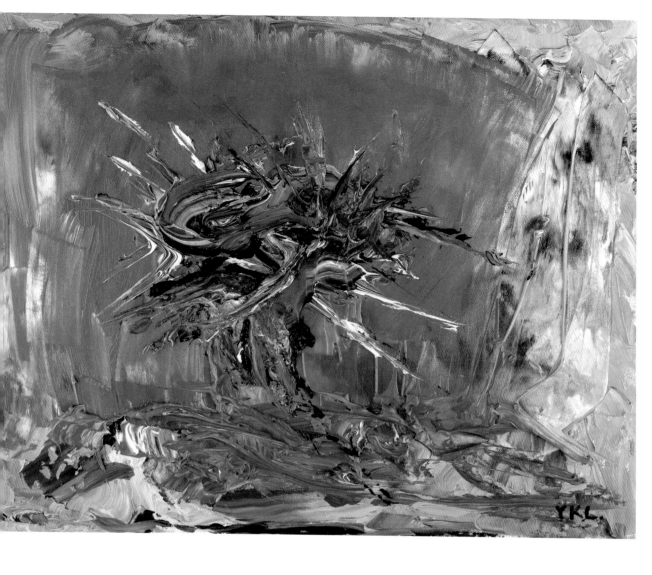

畫名：激

材質：油畫／仿帛麻布

尺寸：45.5x38 cm

作者：李雅山

年份：2018

鐵塔凌雲
The Glorious Tower

巴黎多變的天空，常顯現美麗夢幻般的神奇色彩，黃昏下的巴黎鐵塔用法國國旗的藍白紅鑲邊點綴，代表它在法國人和全世界人心中的地位。這幅畫是送給好友王商郿小姐和她的兩隻貓。看，他們正在畫的右下方欣賞巴黎鐵塔呢！

The sky in Paris is everchanging and full of mesmorizing colours. The Eiffel Tower decorated with colours of the French Flag stands by the sunset, representing its significance in not only the hearts of people in France, but around the globe. This piece was a gift to my good friend, Miss Wang Shang Yun and her two cats. Look, they are admiring the Eiffle Tower from the bottom right corner!

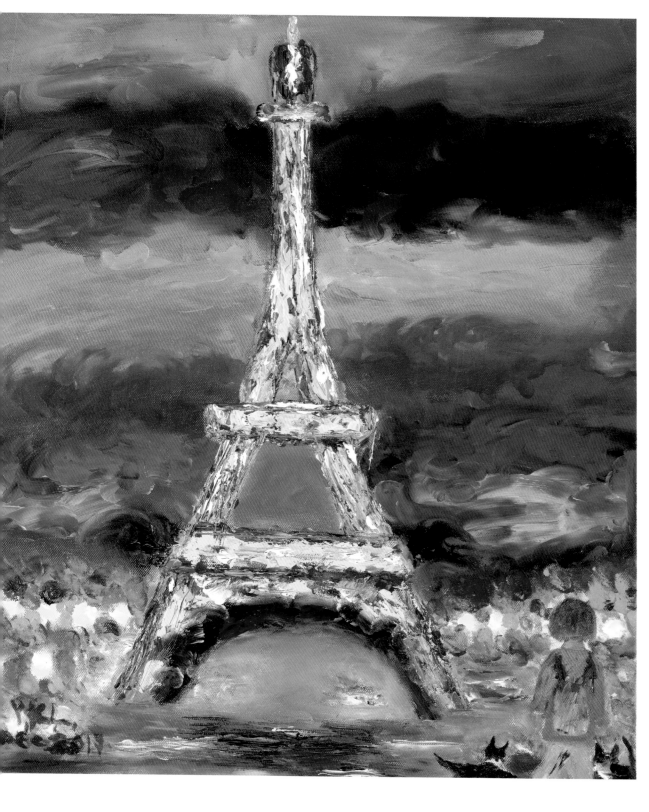

畫名：鐵塔淩雲
材質：油畫／仿亞麻布
尺寸：46x38 cm
作者：李雅康
年份：2017

聖誕夜

Christmas
Eve

2017的聖誕夜，我獨自在台北度過，是夜，畫出心中的感動。我被台北聖誕節的氣氛的紅色、綠色、銀色團團圍住。但心中甚是思念法國的家人、朋友，第一次未能與他們團聚共慶聖誕。畫中塗抹在圈圈氛圍外的顏色是我淡淡的憂傷。

I spent Christmas Eve of 2017 alone in Taipei. The night prompted me to paint what moved my heart. I was surrounded by Taipei's Christmas vibes portrayed by colours of red, green, and silver. It was my first time not spending the Christmas Holidays with family and friends in France. Colours used outside the focal point depict my subtle sorrow.

畫名：聖誕夜2017

材質：油畫 / 仿常麻布

尺寸：46x38 cm

作者：李雅康

年份：2017

繽紛

Vibrant
Colours

2017年的冬天，白內障術後大放光明之日，愉悅興奮之情傳達在畫布上成為燦爛繽紛的瓶花，看清楚後，發現世界如此美麗。

Winter of 2017, I successfully endured the surgery to remove my cataracts. Those days that follow were filled with light. Excitement and joy stirred in me as I painted these vibrant flowers in the vase. With a clear vision, the world's beauty filled my eyes.

畫名 : 繽紛
材質 : 油畫 / 仿亞麻布
尺寸 : 53x41 cm
作者 : 李雅康
年份 : 2017

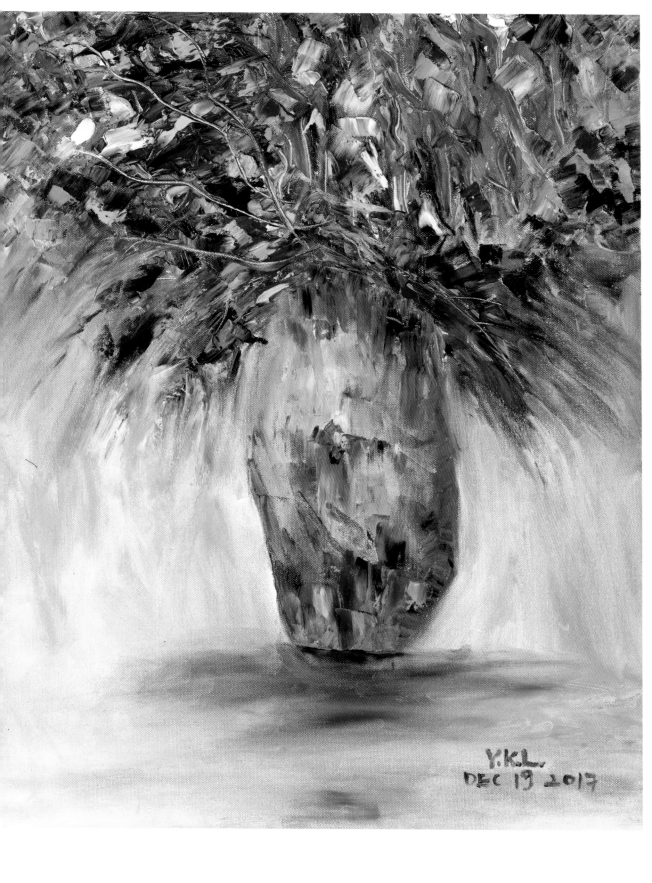

Y.K.L.
DEC 19 2017

畫名 : 夜巴黎
材質 : 油畫 / 仿亞麻布
尺寸 : 60x50 cm
作者 : 李雅康
年份 : 2017

夜巴黎
One night
in Paris

夜晚的巴黎，五顏六色的燈光，倒映在塞納河的水面上，襯托出巴黎鐵塔的簡約貴氣；暈暗柔和的街燈，傾聽著漫步在綠叢中情侶們的誓言，我將自己沉浸在此浪漫安靜的夜晚裡，咀嚼著畫中羅曼蒂克的甜蜜色彩，想像更多夜巴黎的情境。

Paris at night consists of multi-colored lights reflecting on the Seine, acting as accessories to the simple, yet regal Eiffel Tower. Gentle florescent lights perk up to words of promise from the couple among the greens. I allow myself to dwell in this gentle and quiet night, as I take in the sweet, romantic colors while thinking of more nights in Paris.

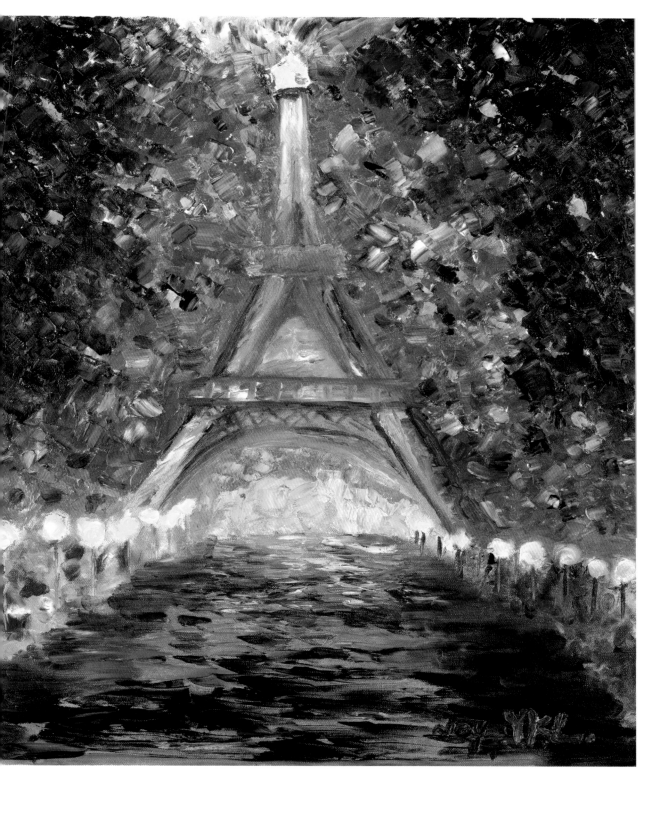

僅獻給我

親愛的

此畫冊出版之際，亦是罹癌滿五週年日，已脫離復發率和死亡率最高的階段。

換言之，我的人生道路還很長，足夠完成我的藝術創作夢想。首先，謝謝這五年來台北榮總醫術精湛的醫療團隊一路的照顧與陪伴。我的新生，不是偶然！遲來後覺的繪畫天賦，是在延續我的「心聲」。

還有親愛的家人和朋友，沒有你，可能就沒有今天的我，也會讓這個世界失去一位熱情的藝術創作者！請放心，現在的「雅康」：健康、強壯、勇敢、樂觀、蓄勢待發，準備創作更震撼人心的美妙作品，請拭目以待！

最後用一句大家常鼓勵我的話來祝福你：常常喜樂！

李雅康 敬上

Dedicated
to my dearest

The publishing date of this work marks the five year anniversary of my cancer diagnoses. I am now past the period I was most at risk of recurrence and death. In other words, I still have a long life to live, enough to fulfill my desire to create art.

First of all, I give great thanks to the team at Taipei Veterans General Hospital, specifically their meticulous treatment team for supporting, and sticking with me throughout my battle. This new life is not a coincidence by chance. My latter found talent for art is a continuation of the voices in my heart.

Also, I give thanks to my dear family and friends. Without you, there would not be an Isabelle right now. Without you, this world would've regretted having a passionate artist. Do not worry, the new Isabelle is healthy, strong, courageous, optomestic, prepared, and ready to create more work that have power to tugs at heartstrings. Please stay tuned !

I gift to you a phrase I have been gifted many times before by others : be joyful, and stay joyful!

Sincerely,

Isabelle

作者簡介

1963年1月3日出生於台灣高雄，1989年至法國巴黎定居。2013年罹患癌症後開始繪畫生涯，擅長抽象畫，在無拘束的想像空間中用心的力量揮灑個人情感與理想，畫刀跳躍運用傳達生命動力，相信，若用心去調色，每種顏色都將是畫中精彩的對白。期盼藉此激發賞畫人心靈的共鳴。

曾參加2015、2016年法國Marne la Vallēe 地區藝術家聯展。

Artist Introduction

Isabelle LEE was born in Kaohsiung, Taiwan on January 3rd, 1963. She migrated to Paris, France in 1989. Isabelle began her art journey in 2013 after being diagnosed with cancer. She specializes in abstract art, and creates boldly without limitations. Her strengths come out of her riveting emotions and ambitions. Every stroke dances as if they were communicating messages of motivation and life. She believes that by mixing colours from the heart, every palette can communicate within the canvas. Isabelle hopes for her audience to find belonging and understanding through her work.

李 雅 康

Isabelle Lee

un-
known

Isabelle Lee

李雅康

給我

一個名字

生活美學17

國家圖書館出版品預行編目資料

給我一個名字 / 李雅康著
--初版-- 臺北市：博客思出版事業網：2018.12
ISBN：978-986-97000-2-3 （精裝）

1.油畫 2.畫冊
948.5 107019353

作　　　者：李雅康
美術設計：沈子淮
編　　　輯：沈子淮
執行製作：楊容容
中文校稿：張珊珊
英文翻譯：Gloria Shen
出 版 者：博客思出版事業網
發　　　行：博客思出版事業網
地　　　址：台北市中正區重慶南路1段121號8樓之14
電　　　話：(02)2331-1675或(02)2331-1691
傳　　　真：(02)2382-6225
E—MAIL：books5w@gmail.com或books5w@yahoo.com.tw
網路書店：http://bookstv.com.tw/
　　　　　http://store.pchome.com.tw/yesbooks/
　　　　博客來網路書店、博客思網路書店
　　　　三民書局、金石堂書店

總 經 銷：聯合發行股份有限公司
電　　　話：(02) 2917-8022　傳 真：(02) 2915-7212
劃撥戶名：蘭臺出版社 帳號：18995335
香港代理：香港聯合零售有限公司
地　　　址：香港新界大蒲汀麗路36號中華商務印刷大樓
　　　　　C&C Building, 36,Ting, Lai, Road, Tai,Po, New,Territories
電　　　話：(852)2150-2100　傳 真：(852)2356-0735
經　　　銷：廈門外圖集團有限公司
地　　　址：廈門市湖里區悅華路8號4樓
電　　　話：86-592-2230177　傳 真：86-592-5365089

出版日期：2018年12月 初版
定　　　價：新臺幣520元整 （精裝）
ISBN：978-986-97000-2-3